little Otou presents ...

the NON-PLANNER* DATEBOOK

* A COLLECTION OF DAYS,

IDEAS, LISTS AND RANDOM

THOUGHTS. ALL IN ONE PLACE.

PARTIALLY CUSTOMIZABLE.

by keri smith

 \sim little Otou presents $^{\sim}$

THE NON PLANNER DATEBOOK
BY KERI SMITH
LO42 © 2009 KERI SMITH
PUBLISHED BY LITTLE OTSU
SECOND EDITION, FIRST PRINTING

PRINTED IN OAKLAND, CA BY 1984
WITH SOY BASED INKS ON
100% POST CONSUMER RECYCLED PAPER.

ALL RIGHTS RESERVED. NO PART OF THIS BOOK MAY BE REPRODUCED WITHOUT WRITTEN PERMISSION FROM THE PUBLISHER EXCEPT FOR REVIEW PURPOSES.

WWW. LITTLE OTSU. COM WWW. KERISMITH. COM

ISBN: 978-1-934378-19-9 12 MONTHS, 96 PAGES

OFFICIAL BOOK OF IMPORTANT THINGS

S M T W T F S 1 2 3 4 5 6 7 8 9 10 11 12 13 14 15 16 17 18 19 20 21 22 23 24 25 26 27 28 29 30 31 JANUARY	S M T W T F S 1 2 3 4 5 6 7 8 9 10 11 12 13 14 15 16 17 18 19 20 21 22 23 24 25 26 27 28 FEBRUARY	S M T W T F S 1 2 3 4 5 6 7 8 9 10 11 12 13 14 15 16 17 18 19 20 21 22 23 24 25 26 27 28 29 30 31 MARCH	S M T W T F S 1 2 3 4 5 6 7 8 9 10 11 12 13 14 15 16 17 18 19 20 21 22 23 24 25 26 27 28 29 30 APRIL	2
S M T W T F S 1 2 3 4 5 6 7 8 9 10 11 12 13 14 15	S M T W T F S 1 2 3 4 5 6 7 8 9 10 11 12 13 14 15 16 17 18 19	S M T W T F S 1 2 3 4 5 6 7 8 9 10 11 12 13 14 15 16 17	S M T W T F S 1 2 3 4 5 6 7 8 9 10 11 12 13 14 15 16 17 18 19 20 21	
16 17 18 19 20 21 22 23 24 25 26 27 28 29 30 31 MAY	20 21 22 23 24 25 26 27 28 29 30 JUNE	18 19 20 21 22 23 24 25 26 27 28 29 30 31 JULY	22 23 24 25 26 27 28 29 30 31 AUGUST	
$\begin{array}{cccccccccccccccccccccccccccccccccccc$	\$ M T W T F S 1 2 3 4 5 6 7 8 9 10 11 12 13 14 15 16 17 18 19 20 21 22 23 24 25 26 27 28 29 30	S M T W T F S 1 2 3 4 5 6 7 8 9 10 11 12 13 14 15 16 17 18 19 20 21 22 23 24 25 26 27 28 29 30	5 M T W T F S 1 2 3 4 5 6 7 8 9 10 11 12 13 14 15 16 17 18 19 20 21 22 23 24 25 26 27 28 29 30 31	0)
SEPTEMBER	31 OCTOBER	NOVEMBER	DECEMBER	
S M T W T F S 1 2 3 4 5 6 7 8 9 10 11 12 13 14 15 1617 18 19 20 21 22 23 24 25 26 27 28 29 30 31 JANUARY	S M T W T F S 1 2 3 4 5 6 7 8 9 10 11 12 13 14 15 16 17 18 19 20 21 22 23 24 25 26 27 28 FEBRUARY	S M T W T F S 1 2 3 4 5 6 7 8 9 10 11 12 13 14 15 16 17 18 19 20 21 22 23 24 25 26 27 28 29 30 31 MARCH	S M T W T F S 1 2 3 4 5 6 7 8 9 10 11 12 13 14 15 16 17 18 19 20 21 22 23 24 25 26 27 28 29 30 APRIL	2
S M T W T F S 1 2 3 4 5 6 7 8 9 10 11 12 13 14 15 16 17 18 19 20 21 22 23 24 25 26 27 28 29 30 31	5 M T W T F S 1 2 3 4 5 6 7 8 9 10 11 12 13 14 15 16 17 18 19 20 21 22 23 24 25 26 27 28 29 30	\$ M T W T F S 1 2 3 4 5 6 7 8 9 10 1112 13 14 15 16 17 18 19 20 21 22 23 24 25 26 27 28 29 30	S M T W T F S 1 2 3 4 5 6 7 8 9 10 11 12 13 14 15 16 17 18 19 20 21 22 23 24 25 26 27 28 29 30 31	
MAY	JUNE	JOLY	AUGUST	
S M T W T F S 1 2 3 4 5 6 7 8 9 10 1112 13 14 15 16 17 18 19 20 21 22 23 24 25 26 27 28 29 30	S M T W T F S 1 2 3 4 5 6 7 8 9 10 11 12 13 14 15 16 17 18 19 20 21 22 23 24 25 26 27 28 29	S M T W T F S 1 2 3 4 5 6 7 8 9 10 11 12 13 14 15 16 17 18 19 20 21 22 23 24 25 26 27 28 29 30	S M T W T F S 1 2 3 4 5 6 7 8 9 10 11 12 13 14 15 16 17 18 19 20 21 22 23 24 25 26 27 28 29 30 31	
SEPTEMBER	30 31 OCTOBER	NOVEMBER	DECEMBER	
S M T W T F S 1 2 3 4 5 6 7 8 9 10 11 12 13 14 15 16 17 18 19 20 21 22 23 24 25 26 27 28 29 30 31	5 M T W T F S 1 2 3 4 5 6 7 8 9 10 11 12 13 14 15 16 17 18 19 20 21 22 23 24 25 26 27 28 29	S M T W T F S 1 2 3 4 5 6 7 8 9 10 11 12 13 14 15 16 17 18 19 20 21 22 23 24 25 26 27 28 29 30 31	S M T W T F S 1 2 3 4 5 6 7 8 9 10 11 12 13 14 15 16 17 18 19 20 21 22 23 24 25 26 27 28 29 30	R)
JANUARY	FEBRUARY	MARCH	****	
S M T W T F S 1 2 3 4 5 6 7 8 9 10 11 12 13 14 15 16 17 18 19 20 21 22 23 24 25 26 27 28 29 30 31	S M T W T F S 1 2 3 4 5 6 7 8 9 10 11 12 13 14 15 16 17 18 19 20 21 22 23 24 25 26 27 28 29 30 JUNE	S M T W T F S 1 2 3 4 5 6 7 8 9 10 11 12 13 14 15 16 17 18 19 20 21 22 23 24 25 26 27 28 29 30 31 JULY	S M T W T F S 1 2 3 4 5 6 7 8 9 10 11 12 13 14 15 16 17 18 19 20 21 22 23 24 25 26 27 28 29 30 31 AUGUST	
S M T W T F S 1 2 3 4 5 6 7 8 9 10 11 12 13 14 15 16 17 18 19 20 21 22 23 24 25 26 27 28 29 30 SEPTEMBER	S M T W T F S 1 2 3 4 5 6 7 8 9 10 11 12 13 14 15 16 17 18 19 20 21 22 23 24 25 26 27 28 29 30 31 OCTOBER	S M T W T F S 1 2 3 4 5 6 7 8 9 10 11 12 13 14 15 16 17 18 19 20 21 22 23 24 25 26 27 28 29 30 NOVEMBER	S M T W T F S 1 2 3 4 5 6 7 8 9 10 11 12 13 14 15 16 17 18 19 20 21 22 23 24 25 26 27 28 29 30 31 DECEMBER	M

I'M GONNA SIT DOWN
RIGHT NOW AND WRITE
ABOUT MY DAY EVEN IF NOTHING
SPECIAL HAPPENED (THE QUIET TIME IS GOOD FOR ME.)

DATE:

NOTE: THIS IS ANOTHER JOURNAL PAGE.

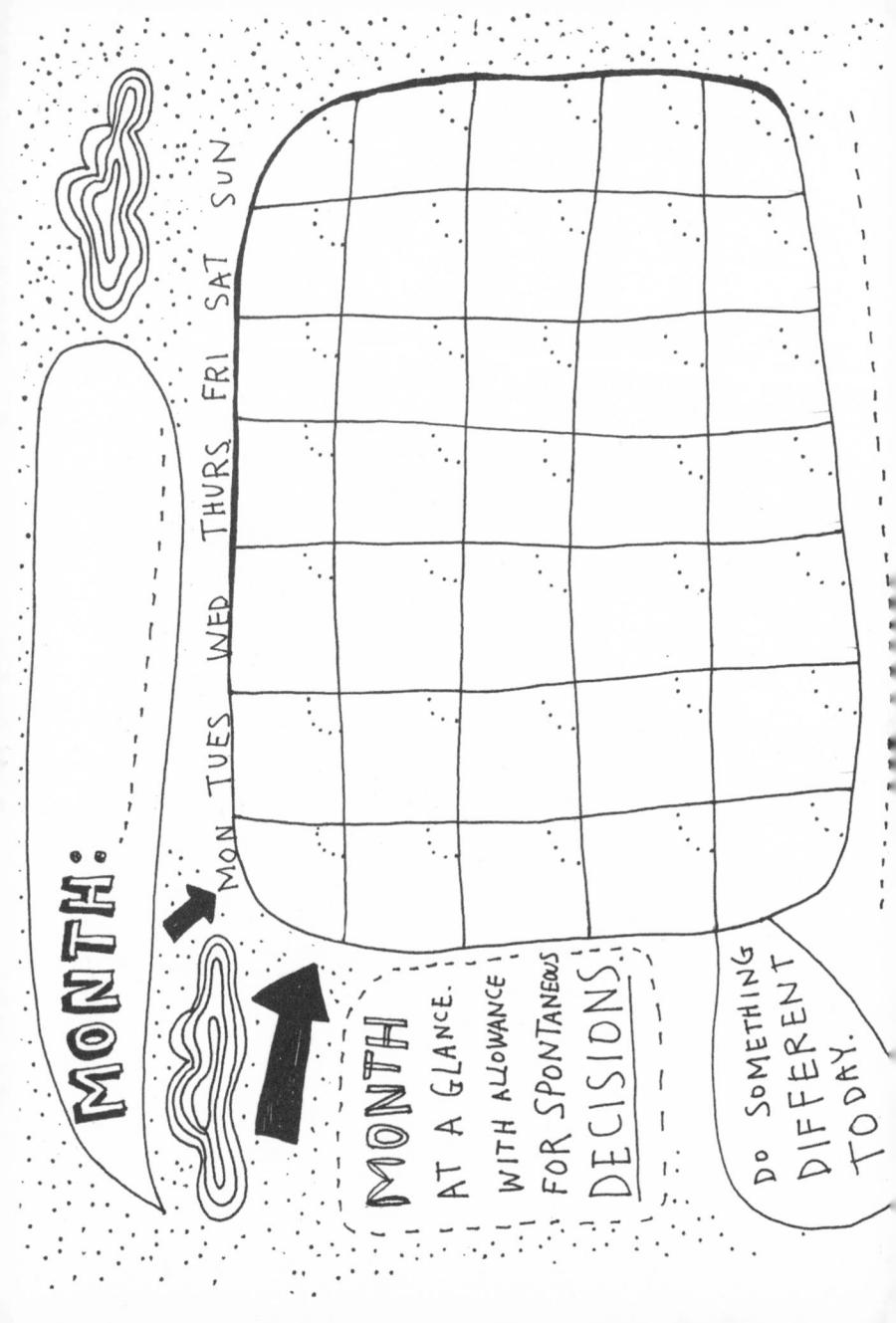

WHAT YOU DID TODAY JOURNAL PAGE.

	DATE	0.		
				\
_				
				_
_				-/
-				/

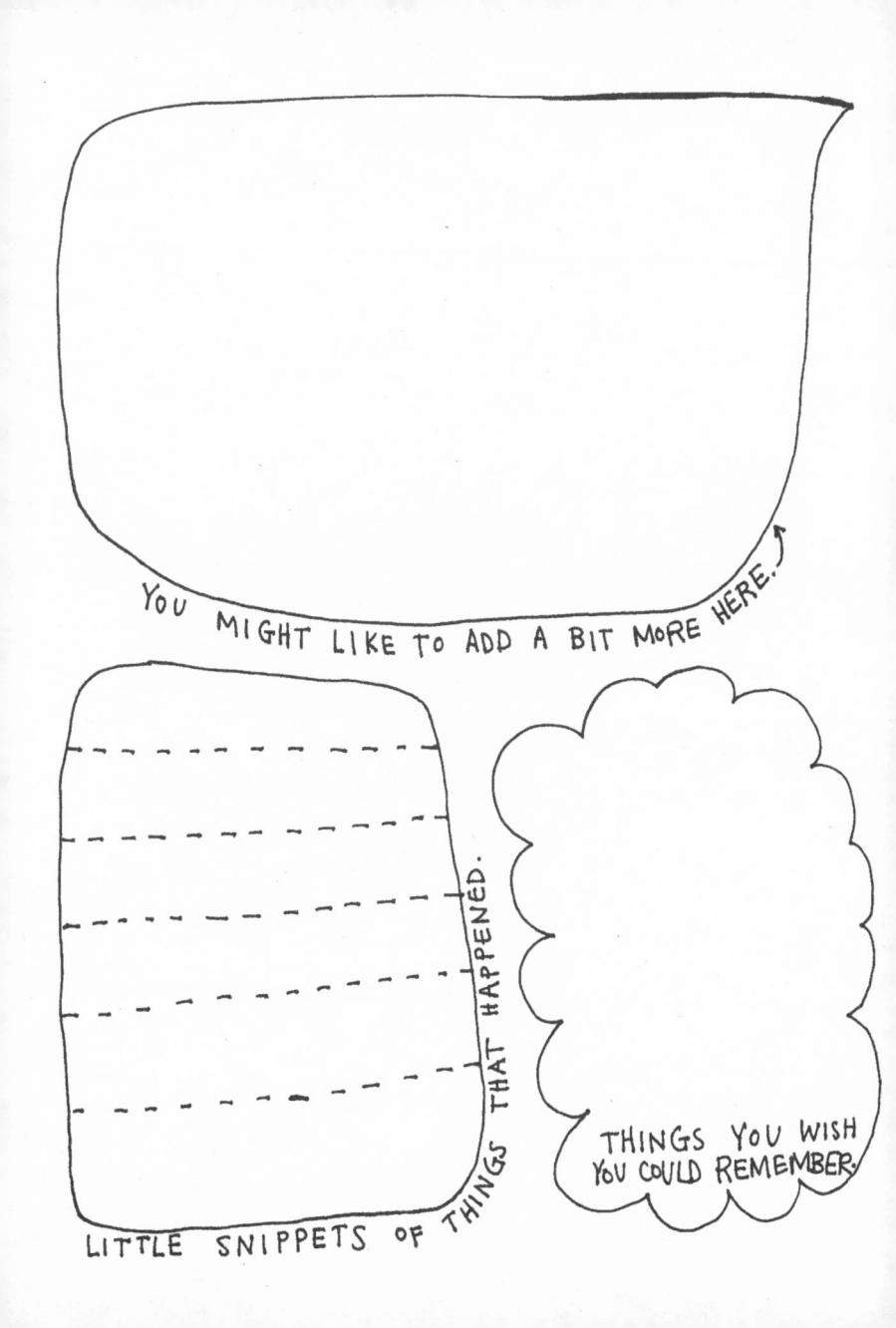

THINGS TO REMEMBER THINGS TO RESEARCH THINGS 2 To MAKE 5 THINGS TO FORGET THIMAS TO SET GO OF. THINGS TO COLLECT

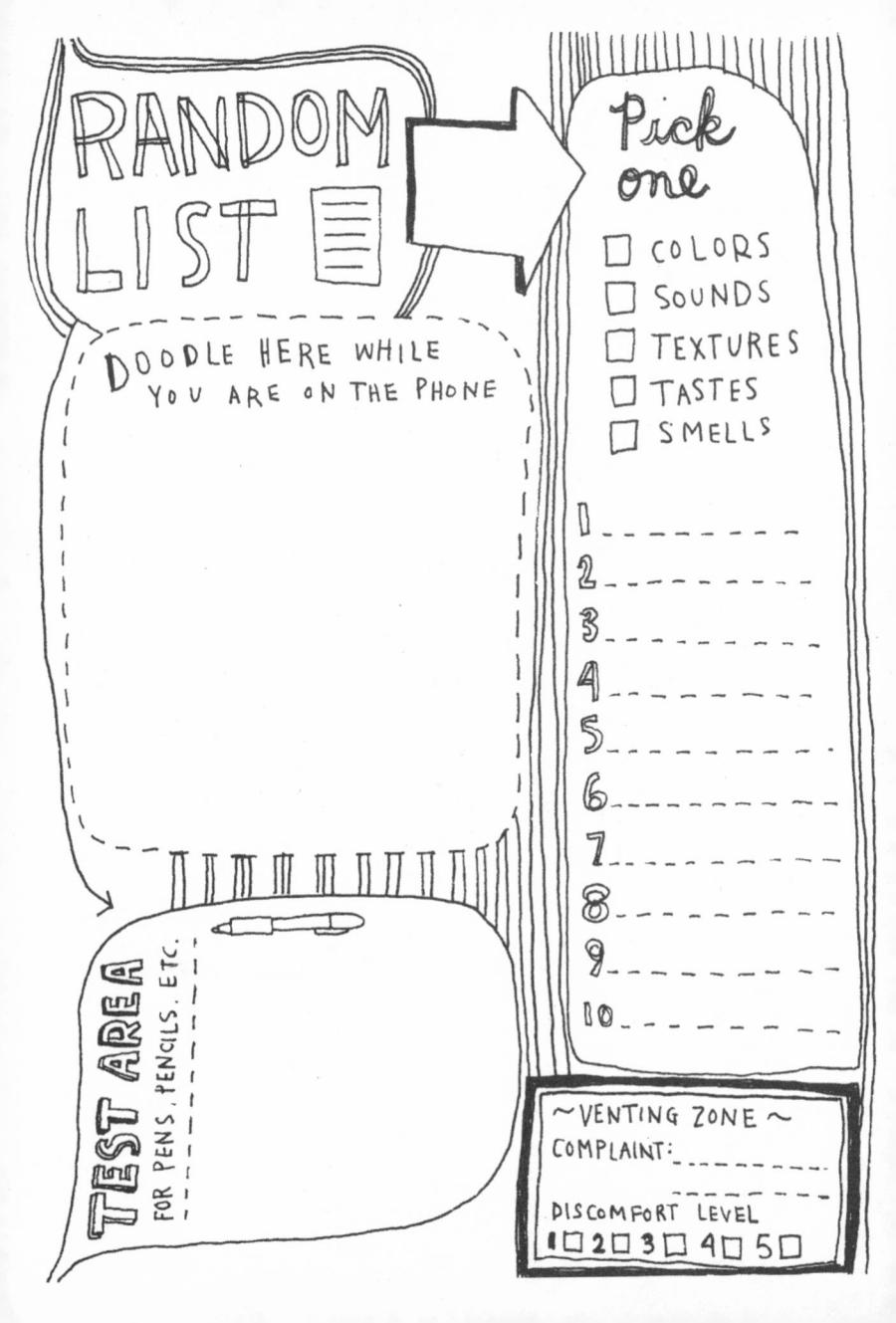

SEMI-BLANK PAGE FOR YOU TO PERSONALIZE.

NOTES, ON VARIOUS THINGS MATCH BOOK COVER NAPKIN SUITCASE SOCK

- !	MO	NTA	A THU	P A	GLA 1 - SA	NCE	NN -
[01	01	
1 1 1 1 1 1 1 1 1 1 1 1 1 1 1 1 1 1 1 1		01	01				
MONTHUS							0
M	0						0
	0			0!			

things you would like to write down (BUT HAVE FULL PERMISSION TO CHANGE YOUR MIND ABOUT LATER*)

mini list OF THINGS YOU SEE WHEN YOU LOOK UP RIGHT NOW.

MINI LIST OF THING YOU

FEEL REALLY GOOD ABOUT RIGHT NOW.

ACCOUNT*OF
INSERT DATE HERE.

BY
YOUR NAME HERE

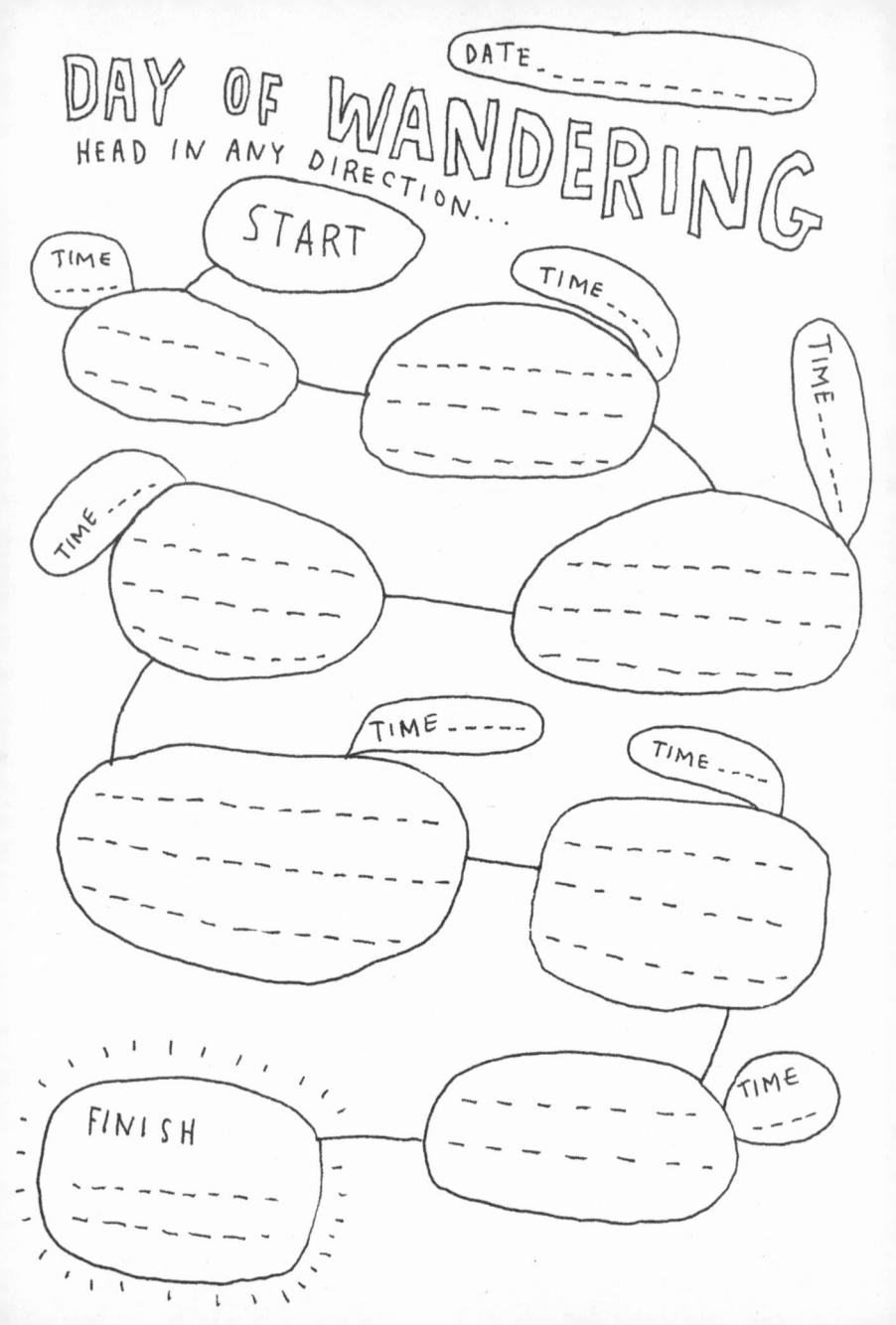

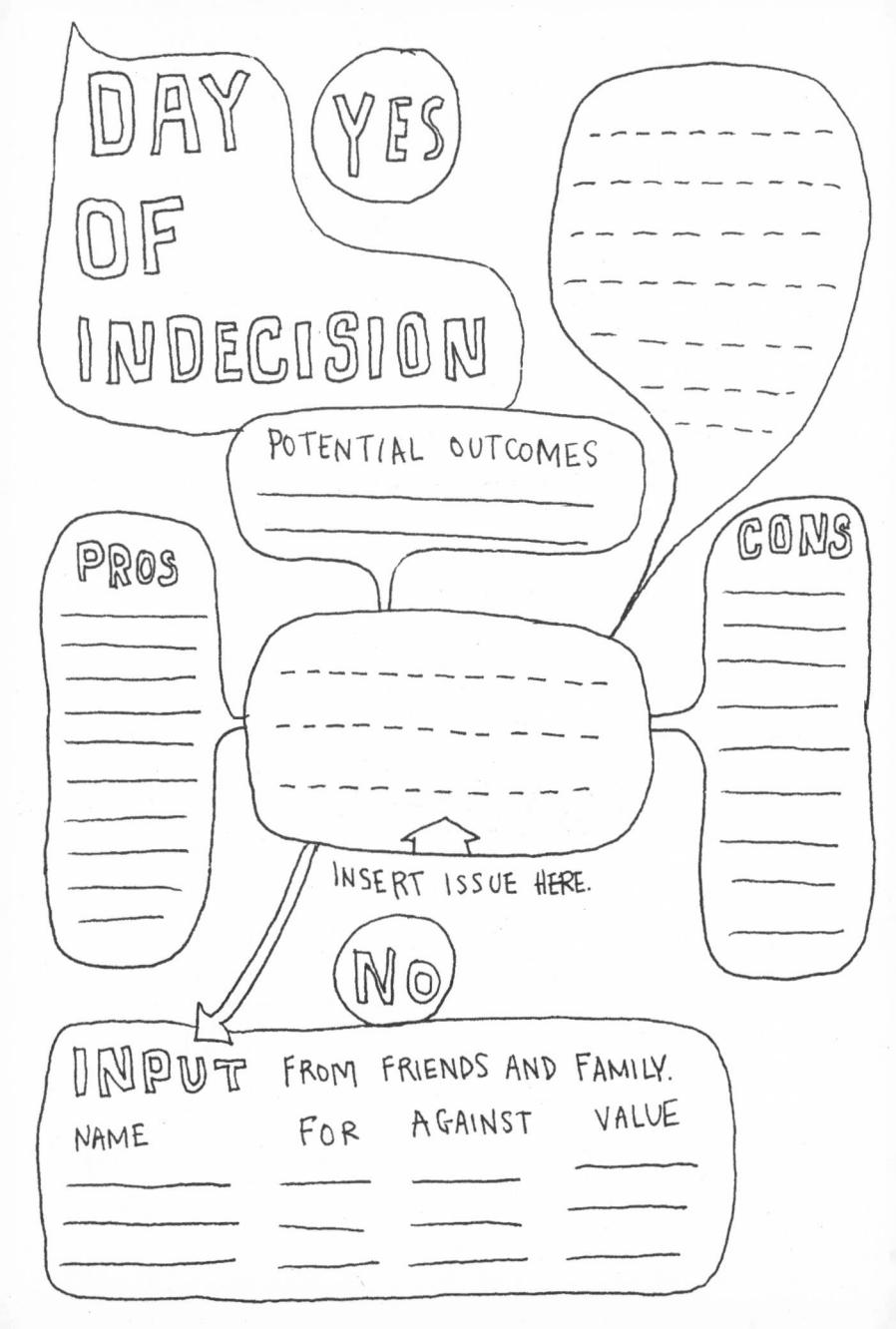

O J AT	GL	ANG	
MONTH IN			
	+		
	-1		
			3
notes and memories	W	THIS	DAYIS
		SMALL THAN TOTHERS	HE /

MOMENTS (WITH NO PRESSURE TO SHARE THEM WITH OTHERS YOU WANT TO.) ANOTHER PAGE FOR JOURNAL ENTRIES YOU DOCUMENT VARIOUS IN WHICH

THE SOMEWHAT* O HAPPY O BORED CUSTOMIZABLE O SAD O TIRED JOUR NAL PAGE O RELAXED O CONTENT O ENERGIZED O WORRIED DATE MOOD LIST SIDENOTE * FOR THE COMPLETELY CUSTOMIZABLE JOURNAL PAGE LOCATE THE "SEMI-BLANK PAGE"

DEAS SPECIAL INSTRUCTIONS SECRET NOTES CUT OUT. DISTRIBUTE.

- BLANK PAGE TO PERSONALIZE. 700

list grafitti YOU CAN WRITE YOUR LISTS ON THESE BUILDINGS AND YOU WON'T GET IN TROUBLE.

month at a glance.

things you would like to write down (BUT HAVE FULL PERMISSION TO CHANGE YOUR MIND ABOUT LATER*)

mini list OF THINGS YOU SEE WHEN YOU LOOK UP RIGHT NOW.

I'M GONNA SIT DOWN
RIGHT NOW AND WRITE
ABOUT MY DAY EVEN IF NOTHING
SPECIAL HAPPENED (THE QUIET TIME IS GOOD FOR ME.)

DATE:

NOTE: THIS IS ANOTHER JOURNAL PAGE.

YOU CAN PUT NOTES IN THE RAINDROPS. OR IN BETWEEN
O SUN SAT GLANCE THURS FRI S TUES Month MON

ATE

NEVER SHOULD WRITE ABOUT THIS DA HAPPEN

707

MAYBE

20

ACCOUNT*OF
INSERT DATE HERE.

WRITTEN

VOUR NAME HERE

MINI LIST OF THING YOU

FEEL REALLY GOOD ABOUT RIGHT NOW.

WHAT YOU DID TODAY JOURNAL PAGE.

	DATE:		
Marrianagandonacion			
-			
-			
			/

SE NOU FOR TO PERSONALIZE. DA CE

DRAW ODD SHAIL

AND COLOR THEM IN. OR TO REASON. SOMETIMES IT HELPS TO DRAW ODD SHAPES

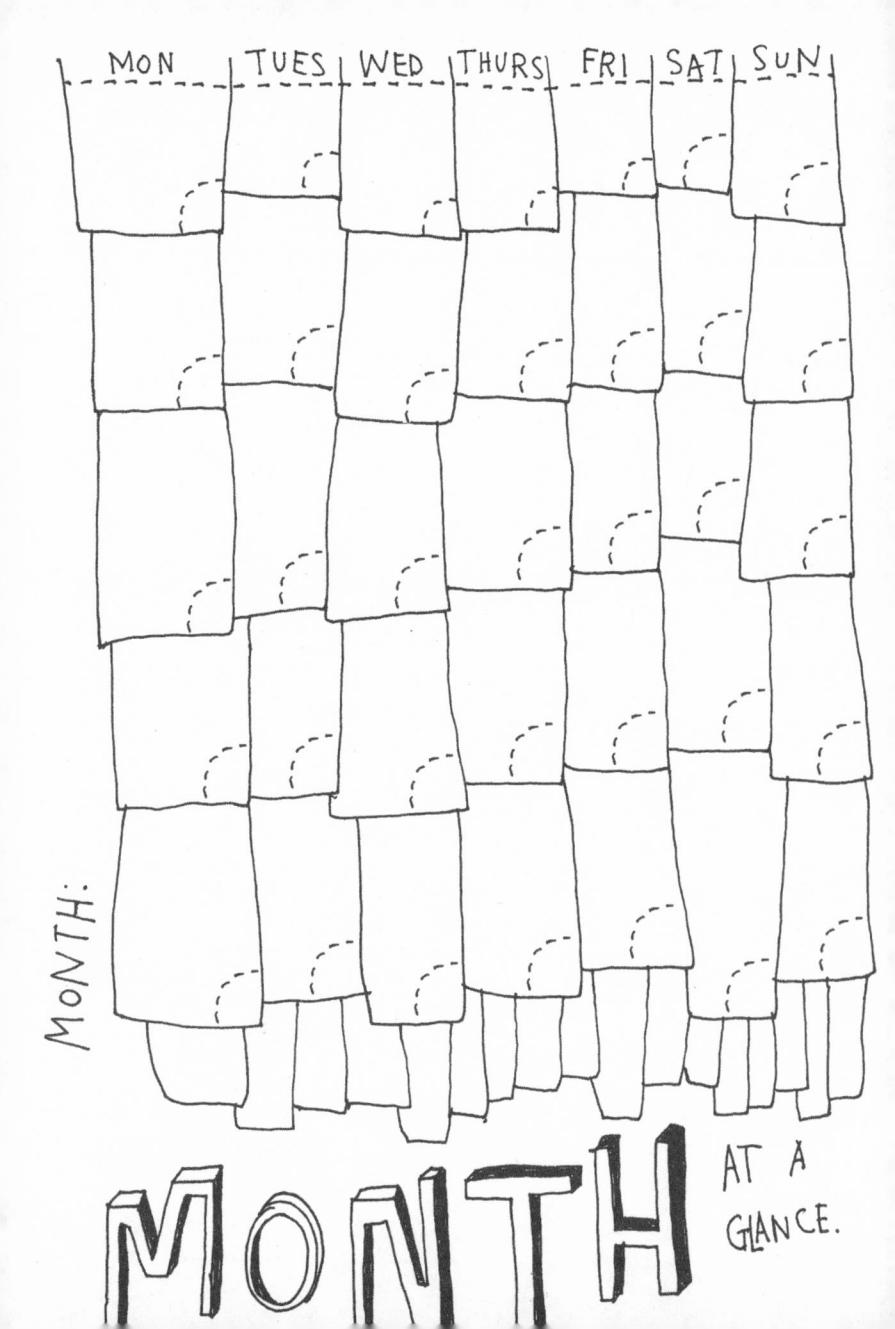

THINGS I DON'T HAVE THE GUTS TO TELL OTHER PEOPLE, (BUT AT LEAST I'M HONEST WITH MYSELF ABOUT).

* THIS SPACE RESERVED FOR EPIPHANIES.

THE SOMEWHAT* O HAPPY O BORED CUSTOMIZABLE O SAD O TIRED JOUR NAL PAGE O RELAXED O CONTENT O ENERGIZED O WORRIED DATE MOOD LIST SIDENOTE * FOR THE COMPLETELY CUSTOMIZABLE JOURNAL PAGE LOCATE THE "SEMI-BLANK PAGE"

IDEAS SPECIAL INSTRUCTIONS SECRET NOTES CUT OUT. DISTRIBUTE.

, SAT SUN TUES · WED , THURS , FRI MON MONTH: Month AT a glance

HERE IS WHERE YOU CAN PUT SOME RANDOM THOUGHTS, BUT YOU DON'T HAVE TO.

NOTE: ACTUALLY YOU CAN PUT ANYTHING YOU LIKE IT'S YOUR BOOK.

YOU CAN ALSO PUT SOME HERE IF

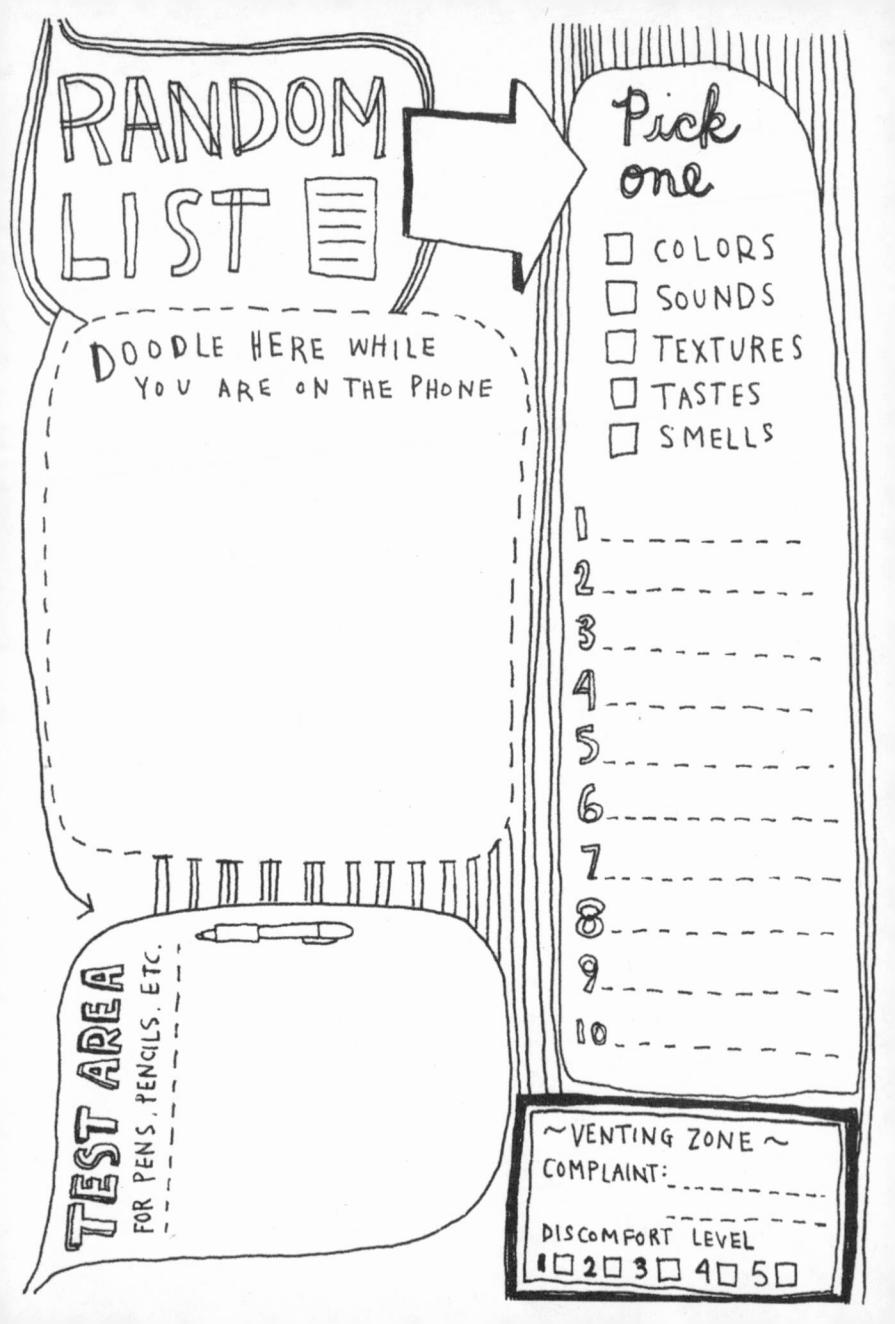

THINGS TO REMEMBER

0.20270011	1	T		-ULK
THINGS TO RESEARCH	(6)	0 11		THINKS
	(3			THINGS
[2]		1	4	MAKE
				TANK
		1\ /	i/	
		1) /	1	
[5]	' \	1 /	1 -	
(',')			1/	
/ / //	()	1	i -	
	, ()		1	R
				5
THINGS		~		/ //
TO FORGET \			//	//
				//
			. –	LET GO OF.
			_ ~	, 0
				18/1
Tance To			/	12 //
THINGS TO COLLECT		_		3////
CORPE			//	'////
		/	NO	/////
		(1	HINGS	////
			//	///
			//	

WHAT YOU DID TODAY JOURNAL PAGE.

	DATE:
-	
-	

MONTH AT A GLANCE

things you would like to write down (BUT HAVE FULL PERMISSION TO CHANGE YOUR MIND ABOUT LATER*)

mini list OF THINGS YOU SEE WHEN YOU LOOK UP RIGHT NOW.

IF YOU ARE STUCK FOR IDEAS MAYBE IT WOULD HELP TO WRITE ON AN ELEPHANT.

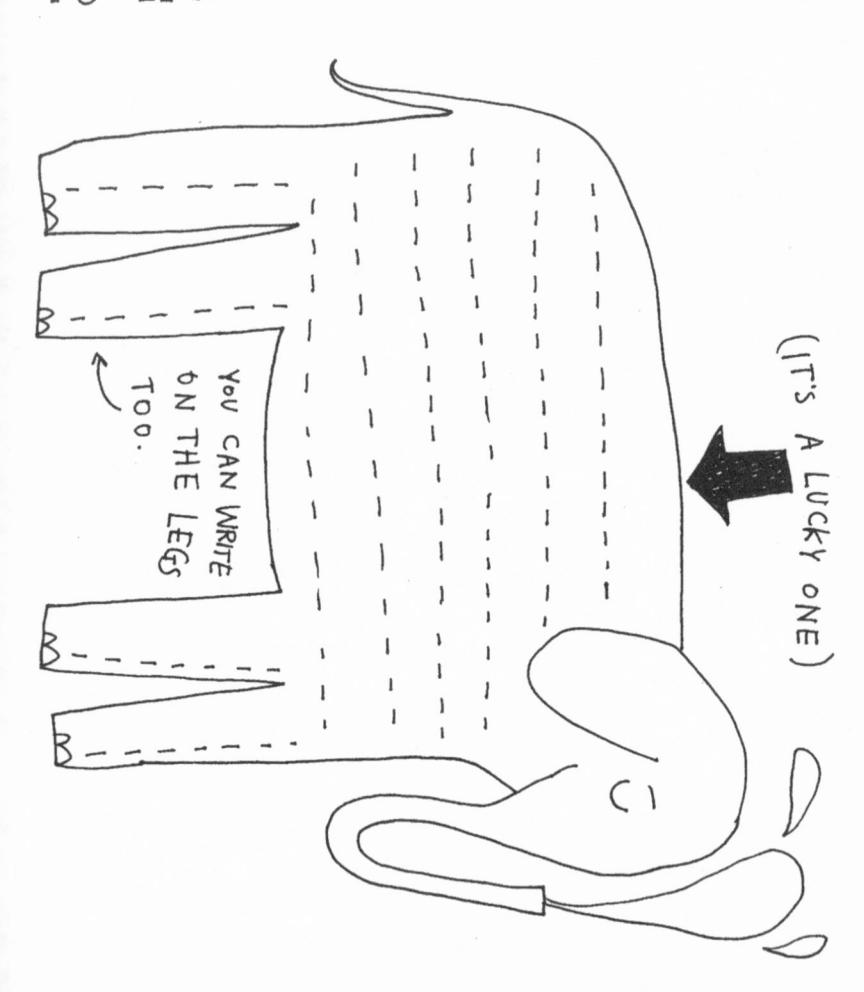

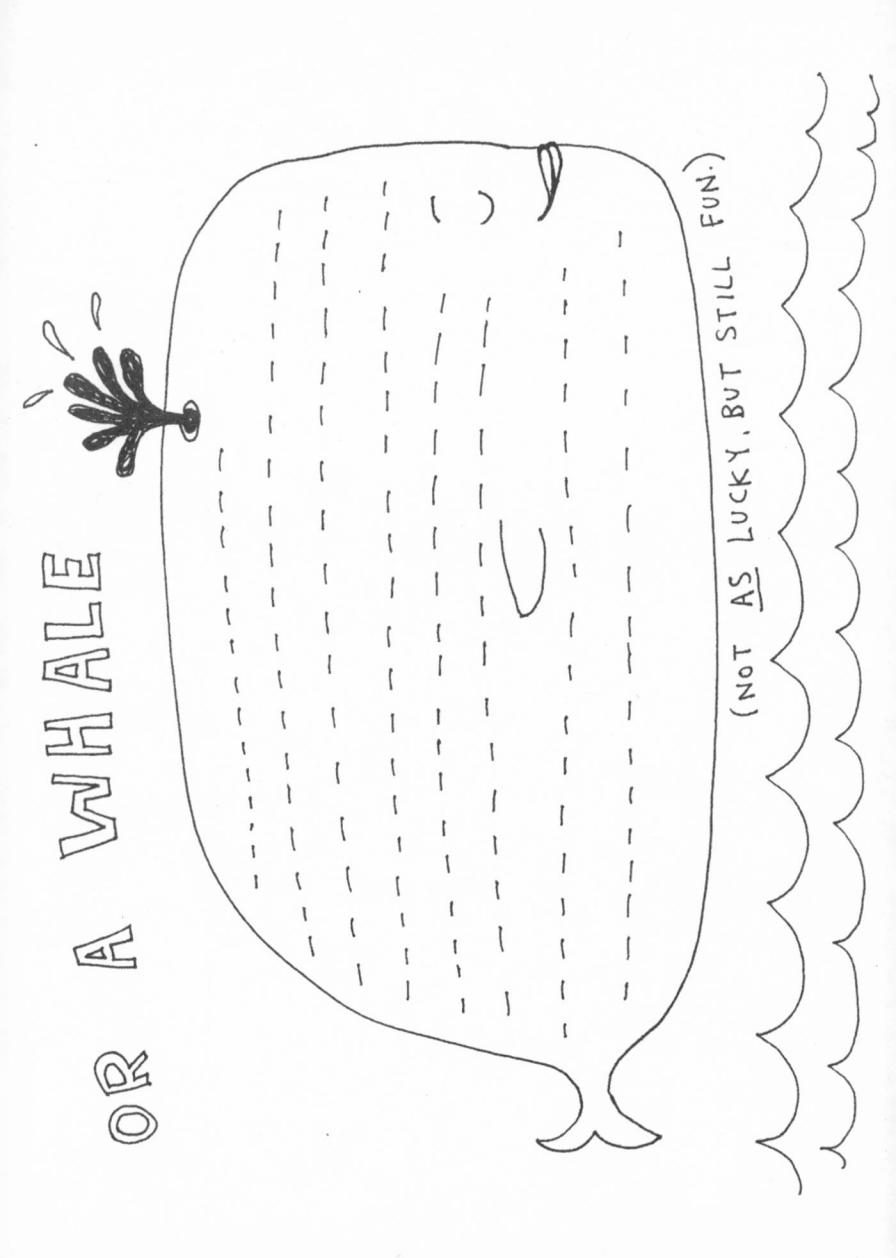

THURS, FRI SAT SUN TUES WED MON menth at a glance MONTH:

I'M GONNA SIT DOWN
RIGHT NOW AND WRITE
ABOUT MY DAY EVEN IF NOTHING
SPECIAL HAPPENED (THE QUIET TIME IS GOOD FOR ME.)

DATE:

NOTE: THIS IS ANOTHER JOURNAL PAGE.

MON THES WED THURS FRI SAT SUN

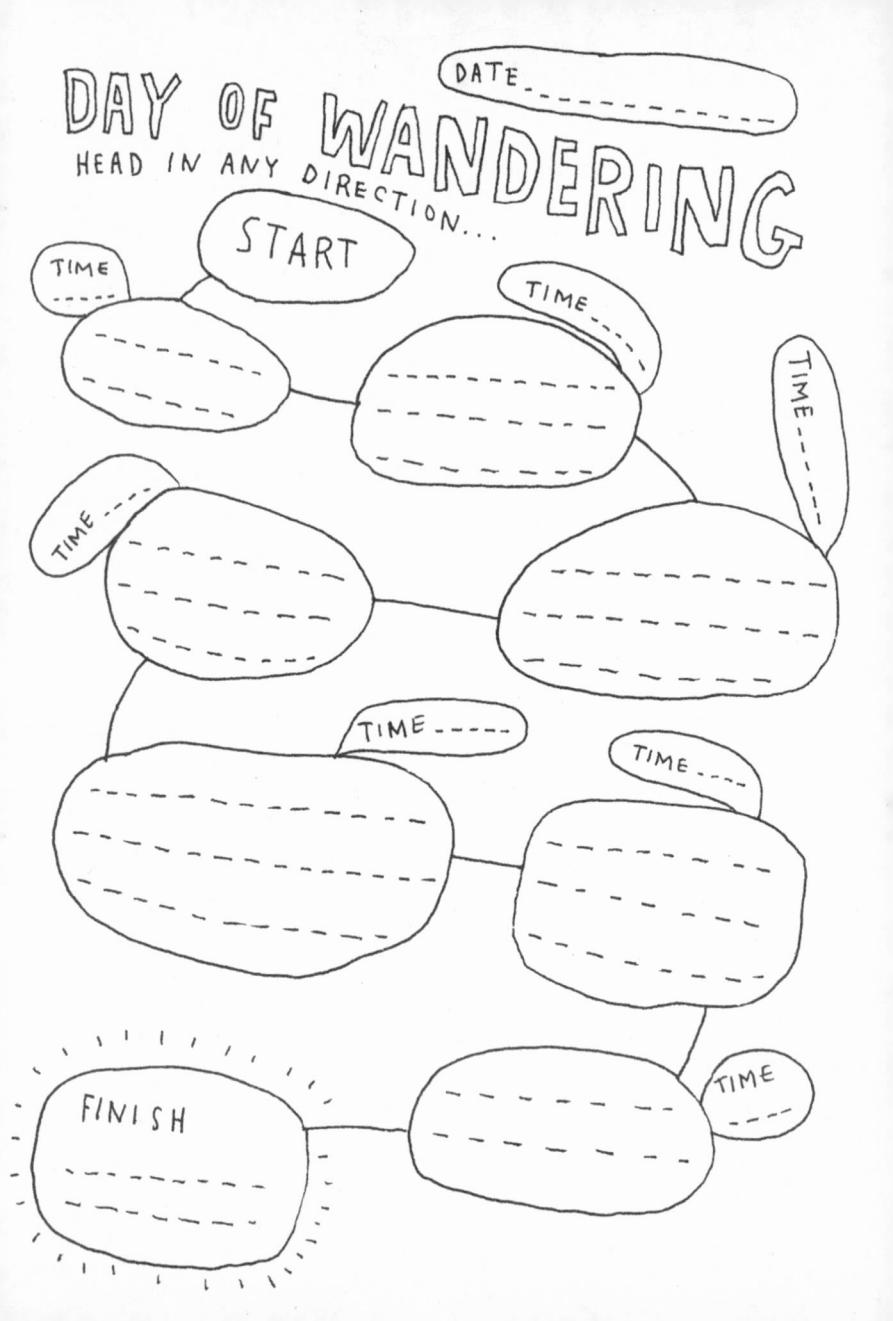

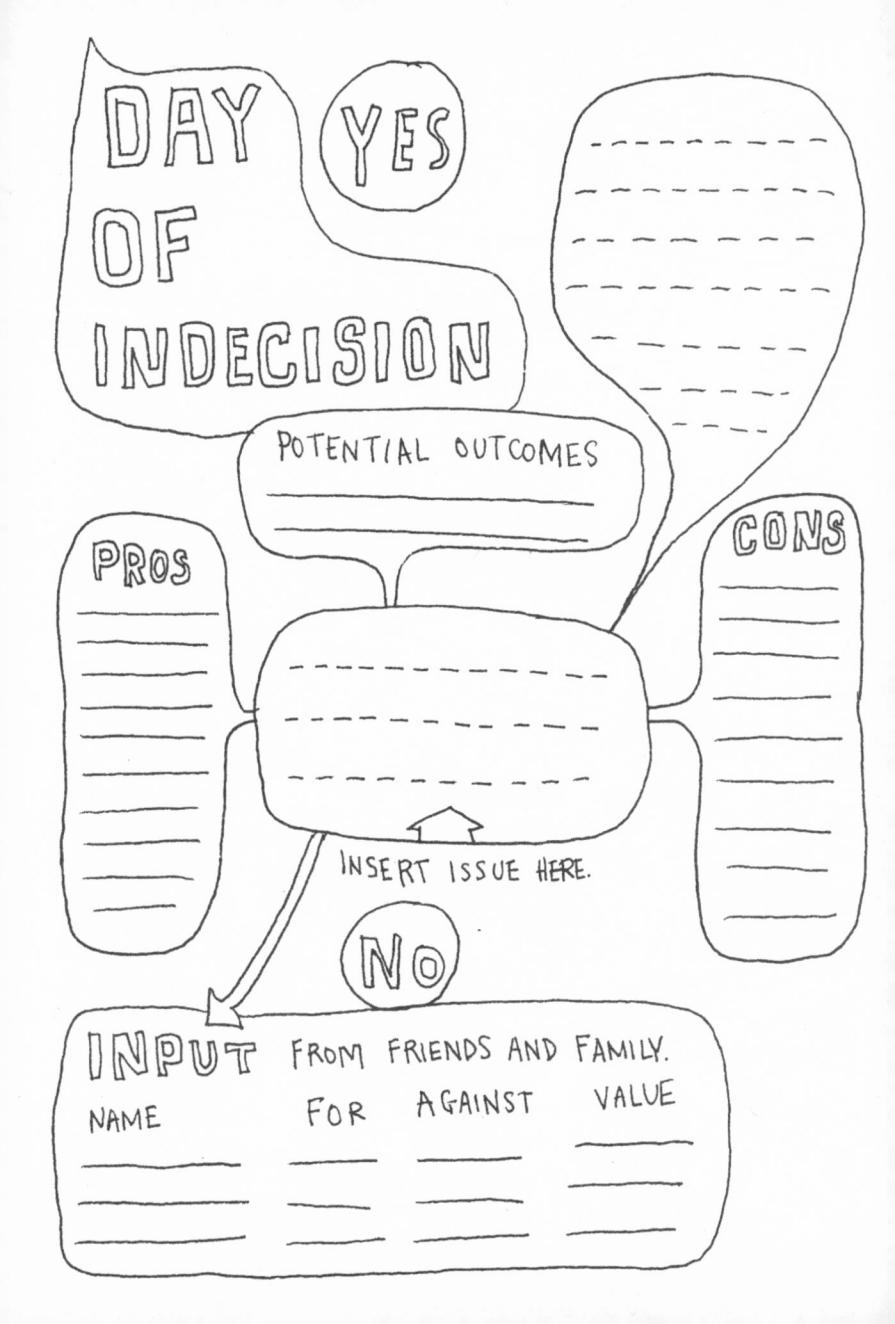

SEMI - BLANK FOR YOU TO PERSONALIZE. FOR PAGE

THE SOMEWHAT* O HAPPY O BORED CUSTOMIZABLE O SAD O TIRED TOUR NAL PAGE O RELAXED O CONTENT O ENERGIZED O WORRIED DATE MOOD LIST SIDENOTE * FOR THE COMPLETELY CUSTOMIZABLE JOURNAL PAGE LOCATE THE "SEMI-BLANK PAGE"

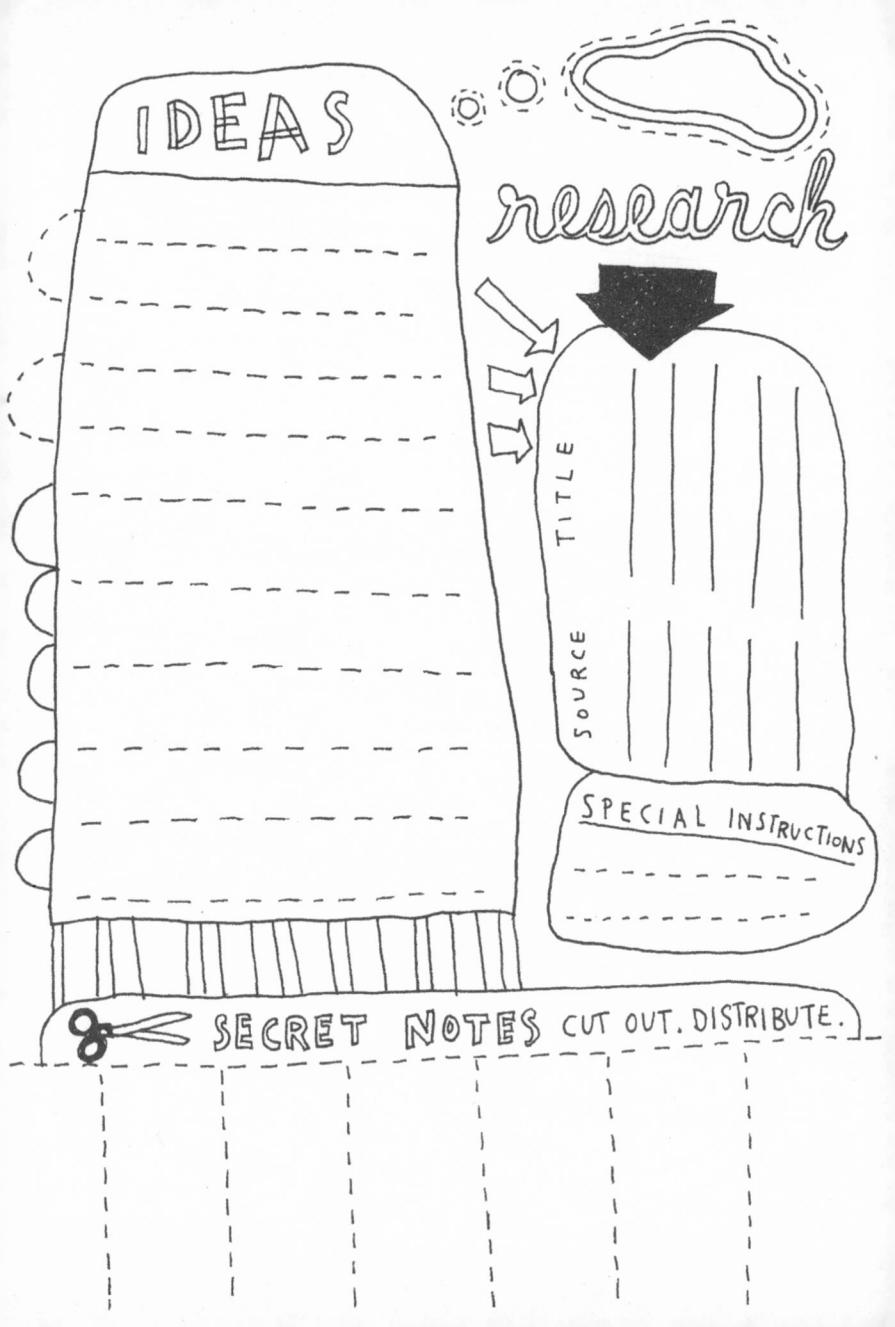

MILL NEVER THIS DA HAPPEN

SHOULD WRITE ABOUT MAYBE YOU 20

HERE IS WHERE YOU CAN PUT SOME RANDOM THOUGHTS, BUT YOU DON'T HAVE TO.

NOTE: ACTUALLY YOU CAN PUT ANYTHING YOU LIKE IT'S YOUR BOOK.

YOU CAN ALSO PUT SOME HERE IF

MONTH:

Della In In In.						
MON	TUES	WED	THURS	FRI	SAT	SUN
:	:	·	·	•		
		÷	*	·	÷	• • • • • • • • • • • • • • • • • • • •
÷.,	:	·	:		÷	÷
•		÷			•	÷
÷	•	:	:,	:	:	÷

-> month at a glance. -

ACCOUNT*OF WRITTEN

YOUR NAME HERE

MINI LIST OF THING YOU FEEL REALLY GOOD ABOUT RIGHT NOW.